GREAT AMERICAN
Women

GREAT AMERICAN WOMEN by Bette Schnitzer

Published by PREMIUM PRESS AMERICA

Copyright © 2005 by Bette Schnitzer

ISBN 0-9637733-8-0

Library of Congress Catalog Card Number 95-78961

PREMIUM PRESS AMERICA gift books are available at special discounts for premiums, sales promotions, fund-raising, or educational use. For details contact the Publisher at P.O. Box 159015, Nashville, TN 37215, or phone toll free (800) 891-7323 or (615)256-8484, or fax us at (615)256-8624.

For more information visit our web site at *www.premiumpressamerica.com*.
Edited by Barbara Bartels
Cover and Interior Design by Bob Bubnis/BookSetters
First Edition 2005
1 2 3 4 5 6 7 8 9 10

GREAT AMERICAN

Women

A CELEBRATION OF ACHIEVEMENT

Bette Schnitzer

PREMIUM PRESS AMERICA
NASHVILLE, TENNESSEE

This book is dedicated to my mother Helen Blackman and my mother-in-law Mary Jane Schnitzer—two great American women. Their guidance, wisdom and love have helped me become the woman I am today.

ACKNOWLEDGEMENTS

This book would not be a book without the tireless help and editing of my friend Barbara Bartels. She is the grammar queen!

I would also like to thank Lanier Brandau for her help and good ideas.

Special thanks to my husband, George. His patience and not-so-gentle nudging made this book a reality.

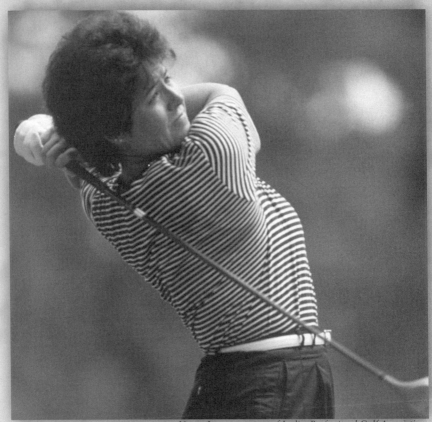

Nancy Lopez, courtesy of Ladies Professional Golf Association

NANCY LOPEZ

Anna Jarvis wanted to honor her mother. In fact, she worked for seven years in Grafton, West Virginia, to establish a day to honor all mothers. She began a letter writing campaign that persuaded almost every state to celebrate a Mother's Day by 1913. In 1914 President Woodrow Wilson signed a joint resolution recommending that government offices do the same. And, in 1915, he proclaimed the second Sunday of each May as national Mother's Day.

On August 18, 1920, the Tennessee Legislature voted on ratifying the 19th amendment which insured women the right to vote. This had been a long, hard struggle and affirmative votes by three-fourths of the states were needed to pass this legislation. Only one more state was needed to ratify the amendment and Tennessee legislators were in a deadlock until Harry Burn remembered a letter his mother wrote him, urging him to do the right thing and vote yes for women's rights. Tennessee passed the 19th amendment and on August 26, 1920, the United States Secretary of State proclaimed the amendment ratified.

In 1911 Juliette Gordon Low of Savannah, Georgia, met Sir Robert-Baden Powell (founder of the Boy Scouts) in England. That meeting inspired Low to found the Girl Scouts of America. The group was first named the Girl Guides. In 1915 Mrs. Low renamed the organization the Girl Scouts of America. It became a national organization, and she was the first president.

On April 15, 1966, women in Columbus, Mississippi, decorated the graves of Confederate and Union soldiers in Friendship Cemetery. This gesture became known as Decoration Day, the beginning of what we now observe as Memorial Day.

Anna Taylor, in 1901, became the first woman to survive going over Niagara Falls alone in a barrel.

In 1968 Democrat Shirley Chisholm of New York made history as the first black woman elected to Congress.

The Susan G. Komen Foundation was established in 1982 in honor of her sister by Nancy Goldman Brinker after Suzy died of breast cancer at the age of 38. For over 20 years, the organization has been a global leader in its research and outreach programs, fighting to eradicate breast cancer. One of its events is the Komen Race for the Cure, the largest series of 5 K runs/fitness walks in the world, which raises millions of dollars for research.

In 1921 Alice Robertson became the first woman to lead the U.S. House of Representatives. She was elected to Congress in 1920 from the state of Oklahoma.

Elizabeth Blackwell is well-known for being the first female to earn a medical degree. Blackwell was born in England in 1821 and immigrated to America with her family when she was eleven. She later became an American citizen. She was turned down by eleven medical schools for admission, but was accepted to the Geneva School in 1848 and earned her medical degree in 1849.

Talk show host Oprah Winfrey has achieved an impressive career in television and movies. She began her television career as a reporter at the CBS affiliate in Nashville, Tennessee. She worked her way up the broadcasting ladder to become the highest-paid and one of the most popular entertainers ever. According to *Forbes* magazine in 2003, she became the first black woman billionaire. And, in 2004, *Forbes* named her #514 on their list of the World's Richest People.

In 1955 Jean Ross Howard Phelan founded the Whirly Girls, an organization for female helicopter pilots. At this time only 13 women nationwide were licensed to fly helicopters.

When she was 12, Aretha Franklin joined her father on his gospel tours and began her singing career. She had six gold albums and more than 14 gold singles by 1973 when she became the "Queen of Soul."

On May 2, 1970, Diane Crump became the first woman jockey to ride in the Kentucky Derby.

In 1866 Dr. Lucy B. Hobbs was the first woman to obtain a D.D.S. degree, but not the first woman to practice dentistry. Graduating from the Ohio College of Dental Surgery, she had a successful career in Iowa.

Lynette Woodard became the first woman, in 1985, to play professional basketball on an all male team, the Harlem Globetrotters.

Janet Guthrie, in 1976, was the first female race car driver to compete in the Indianapolis 500. She placed ninth at Indy in 1978 with a team she formed, owned and managed. This remains the best finish by a woman at the "500."

Margaret Knight (1838-1914) designed and patented the brown paper bag making machine. Her machine would fold and glue paper bags with square bottoms. Before this, bags were flat and envelope-like. In 1870 she founded the Eastern Paper Bag Company. Paper or plastic?

Bette Clair Nesmith Graham, the founder of the Liquid Paper Corporation, invented the popular "White Out" liquid in her kitchen in 1956. Her son, Mike Nesmith, was a member of the 60s rock and roll group, "The Monkees."

Irma Rombauer wrote her first draft of *The Joy of Cooking* in 1931. She self-published it and sold 3,000 copies. It was updated and released in combination with *Streamlined Cooking* in 1936. That edition sold 1.3 million copies in its first ten years. In 1951 Ms. Rombauer and her daughter, Marion, made another revision to *The Joy of Cooking*. The latest revision was done by her grandson, Ethan Becker, in 1997.

Nancy Lopez started playing golf at age eight. In 1978, her rookie professional year, she won nine tournaments. In 1987 Nancy was the youngest person ever inducted into the Hall of Fame, and in 1997 she won her 48th career title and crossed the $5 million milestone in LPGA earnings. Nancy began her farewell tour in 2002.

In 1972 Sally Preisand of Cincinnati, Ohio, became the first woman rabbi in the United States. Rabbi Preisand has received many honors and awards for her excellent work with youth and women's rights.

Jacqueline Bouvier Kennedy Onassis was married to President John Kennedy. In her role as First Lady, Jackie had intelligence, beauty and cultivated taste. Her interest in the arts inspired an attention to culture never before evident at a national level. The courage she displayed during her husband's assassination won her the admiration of the United States and the world. After the death of her husband Aristotle Onassis, Jackie worked as an editor for Doubleday in New York City. She died in 1994 of cancer.

In 1953 Tenley Albright was the first U.S. woman to attain the World Amateur Figure Skating Championship. She won a gold medal at the 1956 winter Olympics and was the first woman to be a member of the U.S. Olympic Committee.

Twenty-seven years before the 19th amendment was passed, Colorado men in 1893, voted to allow women the right to vote.

In 1985 Wilma Mankiller was the first woman to become Principal Chief of the Cherokee Nation of Oklahoma.

In 1848 Elizabeth Cady Stanton and Lucretia Mott called together the first conference to address women's rights and issues in Seneca Falls, New York. Stanton and Mott created the Declaration of the Seneca Falls Convention, which demanded the rights and respect of women and was modeled after the Declaration of Independence, "We hold these truths to be self-evident, that all men and women are created equal."

In 1901 New Yorkers Mary Harriman Rumsey and Nathalie Henderson founded the Junior League. Their goal in forming the organization was to boost volunteerism and to be socially responsible for the conditions of their communities and neighbors. Today the League is active in cities throughout the country.

The daughter of sharecroppers, Linda Chavez-Thompson worked as an agricultural laborer before joining the labor union, rising through the ranks of the AFL-CIO to become the first person of color and the first woman to become its Executive Vice President in 1995.

Sara Breedlove Walker invented the "Walker Method" for straightening African-American hair in 1905. Mrs. Walker invented her line of products and established the sales technique that firms such as Avon has since copied. Her company, the Madame C. J. Walker Manufacturing Company became one of the biggest employers of African-American women in the country, and Mrs. Walker became the first African-American woman to become a millionaire. In 1917 her company was the largest African-American owned business in the United States.

Sportscaster Phyllis George, Miss America of 1970, was the first woman to co-host a Super Bowl game in 1977.

In 1937 Gale Sondergaard became the first woman to receive an Academy Award for best supporting actress for *Anthony Adverse*, which was her first film. Gale was also the inspiration for Disney's Wicked Queen in *Snow White and the Seven Dwarfs*.

In 1978 NASA (National Aeronautics and Space Administration) named the first female astronauts in the American space program. They were: Anna L. Fisher, M.D.; Shannon Lucid, Ph.D.; Judith A. Resnik, Ph.D.; Sally K. Ride, Ph.D.; Rhea Seddon, M.D., and Kathryn Sullivan, Ph.D. In 1979 Seddon became the first woman to achieve full rank of astronaut. Tragically, in 1986, Resnik was the first female astronaut to die in space.

Patsy Cline's singing career began in 1957 with an appearance on Arthur Godfrey's *Talent Scouts* television show. Ms. Cline was just beginning to taste success as a country singer, with seven hit songs in three years, when a 1963 plane crash cut her career short.

GREAT AMERICAN WOMEN

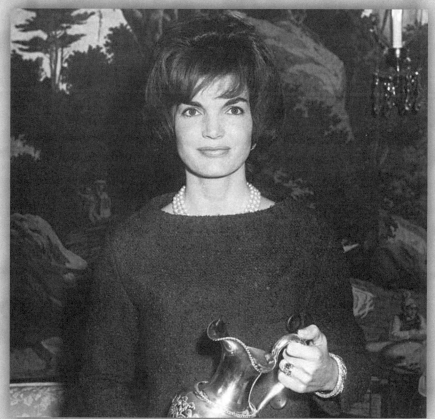

Jacqueline Kennedy, courtesy of the John Fitzgerald Kennedy Library

JACQUELINE BOUVIER KENNEDY ONASSIS

The first waterproof diaper cover, called the "boater," was invented by Marion Donovan in 1949. She financed the manufacturing herself and sold them at Saks Fifth Avenue. Rights to the boater were sold for one million dollars in 1951. Ms. Donovan next invented the disposable diaper. This invention was initially mocked. It took ten years before Pampers marketed her idea.

In 1930 registered nurse Ellen Church became the first male or female flight attendant (then called stewardesses). Ms. Church first suggested the idea of stewardess to the manager of the San Francisco office of Boeing Air Transport and was given the okay to hire seven other registered nurses as stewardess-trainees.

In 1920 Maude Wood Park of Boston, Massachusetts, was asked by Carrie Chapman Catt to be the first national president of the League of Women Voters. Ms. Park also was a creator of the first Parent-Teacher Association (PTA).

From 1927 to 1938, tennis great, Helen Wills Moody, won eight Wimbledon Women's Singles titles. Ms. Moody is the first person to win this many singles. Nicknamed "Little Miss Pokerface" because of her serious demeanor, she won 31 major titles, including seven U.S. and four French championships during her remarkable career.

Bernice Ackerman of Chicago, Illinois, became the first woman weather forecaster in the United States. During World War II she started as a weather observer in the U.S. Navy WAVES.

In 1990 pediatrician Antonia Novello became the first female to be selected as Surgeon General of the United States. A native of Puerto Rico, she worked from 1978 to 1990 in the U.S. Public Health Service at the National Institutes of Health.

"No one can make you feel inferior without your consent."
—Eleanor Roosevelt

Alice Wells was the first woman to receive a regular police appointment to the Police Department of Los Angeles, California, in 1910. Four years later, there were four women on the Los Angeles police force.

In 1877 Helen Magill White became the first woman to earn her Ph.D. She received her degree in Greek drama from Boston University in Massachusetts.

Diana Nyad is one of the world's greatest marathon swimmers. In 1975 she was the first person to swim across Lake Ontario and, later that year, broke a record for swimming around the island of Manhattan in seven hours and fifty-seven minutes.

Emily Blackwell, Elizabeth Blackwell's sister, founded the New York Infirmary for Women and Children. This was the first hospital in the United States for women, and she was the first physician to provide home visits for poor patients.

On September 14, 1975, Elizabeth Ann Seton became the first American-born citizen to be canonized. Mother Seton became a widow at age 29 with five children. She converted to Catholicism and became a nun. She opened the first free parochial school in the U.S. and founded the American branch of the Sisters of Charity.

In 1924 Hazel Hotchkiss and Helen Wills became the first American women's tennis doubles team to win a gold medal in Olympic tennis. During those same Olympics, Ms. Hotchkiss, along with R. Norris Williams, became the first woman to win an Olympic gold medal in mixed doubles tennis. She and Wills also won the women's doubles at Wimbledon that same year.

In 1963 30-year-old Mary Anne Fischer of Aberdeen, South Dakota, made history by giving birth to the first surviving quintuplets. The four girls and one boy expanded the family to twelve!

The Apgar Score System, still used today in hospitals throughout the world to evaluate the health of newborn babies, was devised by anesthesiologist Dr. Virginia Apgar in 1952.

Gospel great Mahalia Jackson started singing in church when she was five. She recorded her first gospel songs in 1935. She made many recordings, toured Europe and the United States, and sang at JFK's inauguration and Martin Luther King, Jr.'s funeral.

In 1914 Alice Gertrude Bryant became one of the first women to be received into the American College of Surgeons. As an ear, nose and throat specialist, she invented the tonsil separator, tongue depressor and forceps used to stabilize broken bones during surgical repair.

Dr. Janet Travel was the first women physician appointed to a United States president. She was the personal physician of President John F. Kennedy.

In 1900 Rose Hawthorne Lathrop, daughter of writer Nathaniel Hawthorne, created the first hospice for the care of terminally ill patients in New York City. In 1900, after the death of her husband, Rose became a nun.

In 1974 Lanny Moss became the first woman to manage a professional minor league baseball team, the Portland Mavericks.

Interested in first-aid because she nursed soldiers during the Civil War and concerned about the need for supplies, Clara Barton devised and implemented a program to collect and distribute supplies to hospitals, camps and the battlefield. Ms. Barton heard about the International Committee of the Red Cross. She worked with them, putting up military hospitals. She then came home to America and worked for five years to form the American Red Cross. Her hard work and dreams became a reality in 1881 when she became the first president of the American Red Cross and operated in that capacity until 1904.

In 1869 Arabella "Bell" Babb Mansfield was the first American woman to become a member of the bar. After graduating at the top of the class at Wesleyan University, Ms. Mansfield was not admitted to the Iowa bar with her husband, also a candidate for the Iowa bar, and other male candidates because the Iowa code provided that "any white male person" was admissible. Liberal Judge Francis Springer interpreted the law to mean that females should not be excluded.

Dr. Agnes Fay Morgan was the first person to prove, in laboratory experiments at the University of California at Berkely, the interrelationships between vitamin and hormone activity and their effects on health. She was also the first person to connect gray hair with a vitamin deficiency.

Lynn Oliver was the first full-time paid woman fire chief in America. She served as chief of the Mercer Island Fire Department in Washington in the 1980's.

Caresse Crosby, whose real name was Mary Jacob, patented the brassiere. She took two silk handkerchiefs and sewed them together with ribbon. She received a United States patent for the "backless brassiere" in 1914. She sold all rights to the Warner Brothers Corset Company for $1,500. The patent was later estimated to be valued at $15 million.

Attorney Faith Seidenberg was victorious in one of the most publicized early cases brought against bars for restricting women (*Seidenberg v. McSorley's*, June 1970), and was one of three attorneys who brought suit requiring the United States Equal Employment Opportunity Commission to outlaw separate "male" and "female" jobs in newspaper job listings.

In 1946 Edith Houghton became the first woman scout for a major league baseball team, the Philadelphia Phillies.

"I cannot and will not cut my conscience to fit this year's fashions."—Lillian Hellman

The first famous woman fashion photographer was Louise Dahl-Wolf. Her work first appeared in *Vanity Fair* in 1933, and she was hired by *Harper's Bazaar* in 1937. She was one of the first photographers to travel to exotic places to locate settings for fashion stories.

Margo Oberg was the first woman to achieve five surfing titles. She started winning at age 12 when she beat 50 boys in her division in a contest in LaJolla, California. In 1975 she won the Hang Ten International at Malibu Beach—the first surfing competition for women.

In 1981 Katharine Hepburn won her fourth Best Actress Academy Award for *On Golden Pond*, making her the only actress to ever receive four Best Actress Academy Awards. Her first was in 1933 for *Morning Glory*, and in 1967 she won her second for *Guess Who's Coming to Dinner*. The third Academy Award was for *The Lion* in Winter in 1968. Katharine Hepburn died at age 96 on June 29, 2003.

In 1959 Ruth Handler created the Barbie doll, named for her daughter. Several years later Handler created the Ken doll, which was named for her son. Ms. Handler and her husband, Elliot, founded Mattel, Inc., one of the largest toy manufacturers in the world. Barbie and Ken "separated" as a couple in 2004.

In 1870 the University of Michigan became the first state university to admit women into medical school.

In 1975 Kathleen Nolan was elected first woman president of the Screen Actors Guild. Nolan was not the choice of the nominating committee—they wanted a man. She came onto the ballot as an independent petition candidate and won with over 3,000 more votes than her closest opponent.

Bonnie Tiburzi of Pompano Beach, Florida, holds the honor of being the first woman hired as a jet pilot by a major American commercial airline. In 1973 she joined the crew on an American Airlines Boeing 727 as third officer (pilot).

Sworn in on March 4, 1933, Frances Perkins was the first woman ever named to a President's cabinet in the United States. As Franklin D. Roosevelt's Secretary of Labor, she spent more than 20 years in the field of labor.

Bleva Lockwood drafted the bill that would allow women the same right to practice law as men. After three years of lobbying, President Hayes signed the bill in 1879, enabling women to plead cases before the Supreme Court. That same year, Bleva Lockwood became the first female attorney to argue a case before the U.S. Supreme Court. Belva even ran for the President of the United States before women had the right to vote.

From 1971 to 1973 Anne Armstrong was the first woman who served as the national co-chair of the Republican Party. Ms. Armstrong delivered the keynote speech at the Republican National Convention in 1972 and, later that year, was the first Republican woman to have full cabinet status as counselor to President Richard Nixon.

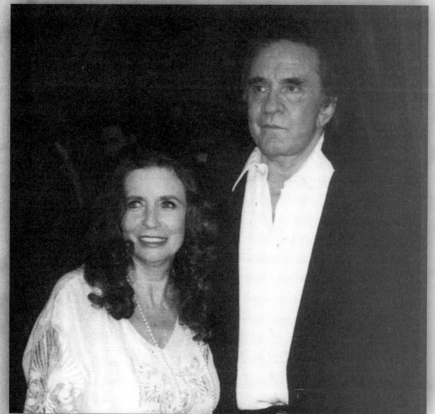

June Carter Cash, courtesy of Peggy Knight

JUNE CARTER CASH

In 1850 Harriet Tubman developed an underground railroad in Maryland to assist escaping slaves. It is reported that she helped as many as 300 people escape to Canada.

Californian Annette Abbott Adams achieved three important firsts in her career. In 1914 Ms. Adams was the first female appointed to the post of Assistant U.S. Attorney. In 1918 she was the first female U.S. District Attorney; and, in 1920, she was the first female appointed U.S. Assistant Attorney General.

Alice S. Marriot, with her husband John, in 1927, decided to start a small restaurant in Washington, D.C. Better known today as the Marriot Corporation, it is made up of restaurants, hotels, cruise lines and fast food chains.

Madeleine Albright became the nation's first woman Secretary of State in 1997, making her the highest-ranking woman in government.

In 1970 Anne Thompson became the first African-American woman prosecutor in the United States. With her 1979 appointment by President Carter, Anne became the first African-American and first woman to be appointed judge of the U.S. District Court (New Jersey).

Eleanor Holmes Norton was the first woman to chair the Equal Employment Opportunity Commission. She was appointed by President Jimmy Carter in 1977. Eleanor was one of the few African-American female law students in the 1960s, receiving her law degree and Masters in American Studies from Yale University. Eleanor started her seventh term as Congresswoman for Washington, D.C., in 2002 and has been awarded over fifty honorary degrees.

In 1986 teacher Christa McAuliffe of Concord, New Hampshire, became the first non-astronaut member of a space mission. She was a member of the space shuttle Challenger and, tragically, one of the first two women to die in space.

Since 1977 women have been able to earn wings as U.S. Air Force pilots. Women in the Air Force were not allowed to fly in combat until 1993.

In 1911 Harriet Quimby became the first women to receive a pilot's license. In 1912 she was also the first woman to fly across the English Channel.

Lt. Col. Jacquelyn Susan "Jackie" Parker is the first American woman to become F-16 Combat Qualified. Jackie started to fly when she was eleven and was a mission controller for NASA by age eighteen. She has received multiple awards such as the Gathering of Greats and the Ground Breaker Award.

In 1955 Marian Anderson became the first African-American soloist in the Metropolitan Opera Company. In 1939, after being barred from Constitution Hall in Washington, D.C., Eleanor Roosevelt arranged for her to sing at the Lincoln Memorial.

In 1985 Penny Harrington took the job of Police Chief of Portland, Oregon, making her the first woman police chief of a major U.S. city.

In 1970 Wyoming became the first state to have a grand jury of both genders.

"Nobody sees a flower, really—it is so small—we haven't time; and to see takes time, like to have a friend takes time."
—Georgia O'Keeffe

Mary Bonner is a highly acclaimed illustrator. She lived and worked in the family home in San Antonio, Texas which, in 1910, was the first home in America to be built completely out of concrete. Originally from Mississippi, the family moved to San Antonio after fire twice destroyed their Mississippi plantation. The home was built by architect Atlee Ayers, copied from an Italian villa originally designed by Michelangelo.

"Since when was genius found respectable?"——Elizabeth Barrett Browning

In 1853 New Yorker Antoinette Brown Blackwell was the first woman ordained as a minister in the United States. She was ordained in the Congregational Church.

In 1946 Mother Frances Xavier Cabrini became the first United States naturalized citizen to be canonized. Born in Italy, Mother Cabrini was sent to American in 1889 by Pope Pius XIII to help with American immigrants. She became a U.S. citizen in 1909 and built an international network of institutions, including Chicago's Columbus Hospital and a number of schools and orphanages. Mother Cabrini is also the founder of the Missionary Sisters of Charity. On July 7, 1946, she became Saint Frances Xavier Cabrini, and many people refer to her as "the saint of the immigrants."

In 1978 Toni Morrison became the first African-American woman to receive the National Book Critics Circle Award for *Song of Solomon*. In 1993 she became the first African-American woman to receive the Nobel Prize for Literature.

Amanda Clement was the first official female umpire in men's baseball. Officiating for Midwestern semi-pro teams from 1905-1911, she designed her own uniform—an ankle-length skirt, a white shirt with black tie and a baseball cap. Extra balls were stored in her blouse!

In 1986 Rear Admiral Grace Murray Hopper had the distinction, at age 80, of being the oldest officer on active duty in all of the armed services. Hopper joined the Navy at age 39 after earning a B.A., M.A. and P.h.D. She worked on the Mark I digital computer during World War II and was known as "the Navy's computer pioneer."

Born on a South Carolina plantation in 1875, Mary McLeod Bethune was the first woman to found a college for African-American women. In 1928 Bethune was invited to the White House by President Calvin Coolidge to attend a child welfare conference. In the 1930s, she became the only African-American woman adviser to President Franklin D. Roosevelt.

Lucille Ball was an innovative performer and businesswoman. She made dozens of movies before she moved to television in 1951. Ms. Ball was executive president and major stockholder of Desilu, which owned *I Love Lucy*, *The Lucy Show* and *Here's Lucy* comedies. The flaming red-haired celebrity sold Desilu for $17 million to Gulf and Western in 1967 and started her own Lucille Ball Productions.

When Anna Mary Moses (known as Grandma Moses) was in her late 70s, she started to paint and became an instant success. In 1940 her work was shown at the Contemporary Unknown American Painters show at the Museum of Modern Art. In 1941 she won the New York State Prize and, in 1949, the Woman's National Press Club Award. Today her paintings are in high demand.

Julie Gardiner married President John Tyler in 1844, becoming the first woman to marry an American president while he was still in office.

Born in 1910 in Pittsburgh, Pennsylvania, Mary Lou Williams was the first successful woman jazz instrumentalist and arranger. She began performing with an orchestra when she was 18. Her arrangements were performed by Duke Ellington and other greats of the day.

Margaret Fogarty Rudkin's neighbors in Fairfield, Connecticut, convinced her to start selling her tasty bread, so she started a mail order business out of her kitchen. This became Pepperidge Farm Bakeries in 1938. The name came from a Pepperidge tree in her yard. By the end of its first year, Pepperidge Farm, Inc. baked 4,000 loaves of bread a week.

Mickey Wright had an outstanding career in golf. In 1963 she held the record for the most titles gained in one season—13; and, in 1964, she attained the lowest recorded score for a woman on an 18-hole course—62. While her lowest recorded score was tied in 1991 by Laura Daviesin, Wright retired in 1980 with a record of eighty-two titles in thirty-five years!

Weight Watchers, one of the most successful weight loss programs in the world, was founded in 1963 by housewife Jean Nidetch in Queens, New York. Weight Watchers began when Jean invited her friends over to discuss the best tips for weight loss.

In 1946 Dorothy Shaver became president of Lord & Taylor and was also the first woman to run a major department store.

In 1901 Jessie Field founded the 4-H Club in Page County, Iowa. The four "H"s stand for head, heart, hands and health.

In 1903 research biologist, Nettie Stevens, at Bryn Mawr College in Pennsylvania, discovered that a specific chromosome determines the sex of a child. She shared the discovery that an X-carrying sperm produced a female embryo and a Y-carrying sperm produced a male embryo with Edmon Beecher Wilson who, independently, reached the same conclusion.

In 1991 Arlette Schweitzer of South Dakota became the first American woman to give birth to her own grandchildren. Ms. Schweitzer's daughter, Christa Uchytil, was born without a uterus. Ms. Schweitzer carried fertilized eggs from her daughter; and, in 1991, her twin grandchildren were born.

Pediatrician Helen Taussig, in 1965, was the first female president of the American Heart Association. In 1944 she identified the cause and cure for cyanosis (blue babies), and the first Blalock-Taussig operation was developed, which still saves the lives of many infants.

In 1977 Mary Shane was the first woman ever to broadcast play-by-play baseball games. She broadcast the Chicago White Sox on WMAQ radio.

From 1943 to 1947, Dr. Leona Libby was a member of the group of scientists who built the first nuclear reactor. She was an early pioneer in nuclear energy technology.

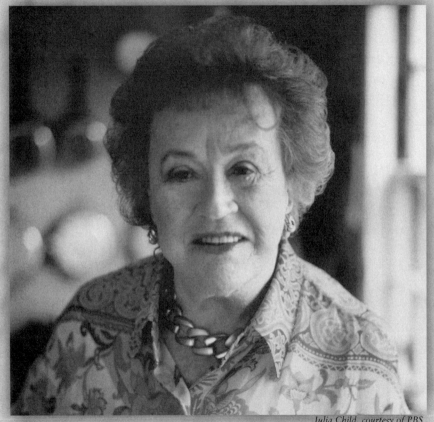

GREAT AMERICAN WOMEN

Julia Child, courtesy of PBS

JULIA CHILD

Lillian Moller Gilbreth became a role model for working mothers and the matriarch character for the book, *Cheaper By the Dozen*. A partner and consulting engineer with her husband Frank, they were pioneers in the 1920s and 30s in time-motion research. Ms. Gilbreth, mother to six boys and six girls, developed new ideas in devices for the handicapped and is famous for designing kitchens with work surfaces that adapted to the disabled individual. She also developed shelves in refrigerator doors and step-on trash cans.

In 1963 Nancy Lotsey became the first girl to play in organized baseball with boys when she was allowed to play in the New Jersey Small-Fry League.

Bessie Gotlieb, advocate of senior citizens rights, helped organize and became the first female board officer of the National Council of Senior Citizens. She was a staunch fighter for health insurance for seniors and witnessed the signing of the Medicare law in 1965.

In 1908 E. Lillian Todd, once a stenographer at the U.S. Patent Office, became the first woman to design an airplane. The unique plane could be collapsed to one-third its flying size, making it easy to transport.

In 1873 Massachusetts native, Ellen Swallow Richards, was the first woman to graduate from MIT and was the founder of home economics as both a science and profession. Ms. Richards, an innovative sanitary chemist (pure water, air and food), was the first president of the American Home Economics Association. In 1881 Ms. Richards also became the founder of the American Association of University Women.

Composer and arranger Ruth Crawford Seeger was the first woman to earn a Guggenheim Fellowship for composition. She is best known for her collections and arrangements of American folk songs, but was an avant-garde composer in her own right.

In 1860 Ellen Demorest became the first person to design and circulate dress-making patterns. Ms. Demorest and her husband, William, operated a dress shop in New York City. They also published fashion magazines, *Demorest's Illustrated Monthly* and *Mme. Demorest's Mirror of Fashions*. They stapled a dressmaking pattern to each of their magazines and distributed them.

After 121 days of lobbying for the bill, in 1975, Tish Sommers and Laurie Shields saw their hard work pay off when the California legislature passed the country's first Displaced Homemaker Act. The act recognizes homemakers as a part of the work force and established programs and services for displaced homemakers, allowing them education, training, counseling, and other services required for independence and security.

In 1974 Mary Louise Smith of Iowa became the first female chairperson of the Republican National Committee.

In 1897 Alice McLellan Birney developed and was the first president of the Parent-Teacher Association in Washington, D.C. First called the National Congress of Mothers, the organization was later renamed the National Congress of Parents and Teachers (PTA) in 1908. The organization remains a strong advocate of education for public schools.

Mary Katherine Goddard achieved two important firsts: in 1775 she became the first female postmaster; and, in 1777, she was the first person to print the Declaration of Independence with all the signers' names on the document.

In 1906 Grace Dodge of New York founded the American faction of the Young Women's Christian Association. Ms. Dodge was also the first president of the National Board of the YWCA.

In the 1960s engineer Beatrice Hicks, one of the founding members of the Society of Women Engineers, was the only woman engineer at Western Electric.

In 1975 Gloria Dean Scott of Houston, Texas, became the first African-American President of the Girl Scouts of America. In her career, Dr. Scott has been a leader in higher education and an advocate of Women's issues. She has been featured in *ESSENCE, Ladies Home Journal, the New York Times,* and *Who's Who Among American Women.*

Fannie Merit Farmer of Boston, Massachusetts, is credited with standardizing ingredient lists in recipe form. In the 1880s, cooking directions were always give by the "pinch" or "handful." It was in 1894 that Farmer first introduced aspiring cooks to "one cup, sifted." She published a highly successful cookbook and founded a cooking school. She also taught nutrition to nurses, hospital dieticians and Harvard Medical School students.

Minnie Pearl, whose real name was Sarah Ophelia Colley Cannon, began entertaining audiences with her off-beat comedy in the 1930s. She joined the Grand Old Opry in 1940 and won numerous awards and distinctions. In 1968 she was elected to the Country Music Hall of Fame.

Nominated by Lyndon B. Johnson on January 26, 1966, New York civil rights attorney, Constance Baker Motley, was appointed the first African-American woman to sit as a federal judge.

In 1940 actress Hattie McDaniel was the first African-American performer to receive a Best Supporting Actress Academy Award. She won the Oscar for her performance of Mammy in *Gone With the Wind*.

Louise Boyd Yeomans King began her gardening career in 1902. She communicated with gardeners worldwide and began writing magazine articles on gardening in 1910. She wrote her first gardening book in 1915 and nine more books followed. In 1913 she founded the Garden Club of American in Alma, Michigan; and, in 1921, she was the first woman to receive the George White Medal of the Massachusetts Horticultural Society. In 1923 she received the Medal of Honor of the Garden Club of America.

Julia Child, the "French Chef," released her first book, *Volume I, Mastering the Art of French* Cooking, in 1961. She first appeared on Boston's public television WGBH-TV and was an instant success. She continued to make television appearances, sharing her culinary talents since 1963. She was a history major at Smith College and joined the Office of Strategic Services (OSS) during World War II.

In 1928 at 27 years of age, Margaret Mead wrote *Coming of Age in Samoa*. It was a best-seller and began a lifetime career of one of the most celebrated anthropologists of our time. Besides her study of the Samoans, she also worked with various tribes in New Guinea and other South Pacific islands and educated the "civilized" world about the ways of these little-known people.

The first woman to publish a newspaper, the *South-Carolina Gazette*, was Elizabeth Timothy in 1738 in Charleston, South Carolina.

Annie Jump Cannon (1863-1941) of Cambridge, Massachusetts, had many claims to fame. She was a brilliant astronomer and was dubbed the "census taker" of the sky. In her lifetime, she classified about 400,000 stars, more than any person before or since. She was the first woman elected as an officer of the American Astronomical Society.

In 1962 marine biologist Rachel Carson brought national attention to the damaging effects of man-made pesticides on our environment in her book *Silent Spring*, which stopped the manufacturing of some pesticides, including DDT. Her efforts led to the establishment of the Environmental Protection Agency and saved the bald eagle, our Nation's symbol, from extinction.

One of the first women to gain fame as a newspaper reporter was Elizabeth Cochrane Seaman, better known as "Nelly Bly." In 1889 Bly earned her celebrity by traveling alone around the world beating the fictional record of Phinneas Fog, hero of Jules Verne's *Around the World in Eighty Days*.

In 1988 Gertrude Elion made history by becoming the first woman to receive a Noble Prize for physiology and medicine and was one of the researchers credited in the discovery of AZT, the drug used in treatment of AIDS. For her many years of researching and developing new drugs, Ms. Elion was received into the National Inventors Hall of Fame in 1991.

In 1967 Dian Fossey of Louisville, Kentucky, went into the rain forests of Rwanda to study mountain gorillas. Sponsored by Louis Leaky, famous naturalist and paleontologist, she was the first person to live among the gorillas and be accepted by these big primates. Her book, *Gorillas in the Mist* (1983), focused attention on preserving these creatures, whose numbers were dwindling from encroachment and poaching.

In 1976 Marlene Sanders made history by becoming Vice-President of ABC and Director of Television Documentaries. This was the highest position held by a woman in television programming at that time.

Helen Rogers Reid (1882-1970) was a journalist and newspaper woman who had an extraordinary career. She started as a social secretary and, ultimately, became president of the legendary New York newspaper, the *Herald Tribune*. Under her direction, women were appointed as book and Sunday magazine editors and women's achievements were routinely reported.

In 1984 Democrat Geraldine Ferraro of New York was the first American woman to be nominated as a vice-presidential candidate by a major political party. Walter Mondale was the party's nominee for President. Ferraro and Mondale were defeated by the re-election of Ronald Regan and George Bush.

The first woman to direct the White House Office of Communications was Magita White in the Ford administration.

In 1970 Cyndi Meagher was the first woman sports columnist for a major metropolitan newspaper, the *Detroit News*.

In 1943 Dr. Myra Logan became the first female surgeon to operate on the human heart. After receiving her pre-medical education at Atlanta University and Columbia, she took her specialty training at Harlem Hospital. She was made a fellow of the American College of Surgeons in 1951.

In 1932 Arkansas resident Hattie Wyatt Caraway was the first woman elected to the United States Senate. A Democrat, Ms. Caraway was also the first woman to chair a committee, the first to conduct Senate hearings and the first to preside over Senate sessions.

Singer Beverly Sills, born Belle Silverman, made her operatic debut at age 17. Nicknamed "Bubbles," she joined the New York City Opera in 1955 and has sung in major opera houses around the world. Along with being the first female chair for the Lincoln Center for the Performing Arts, Beverly became the first female General Director, and then President, of the New York City Opera.

Margaret Bourke-White (1904-1971) was the first female and one of the four original photographers of *Life* magazine. Her work was on the cover and inside the first issue of the magazine. She was also the first female photographer authorized by the Army Air Forces in World War II.

In 1946 the first American dancer to become a prima ballerina was Maria Tallchief. Ms. Tallchief married choreographer George Balanchine in 1946. He choreographed her most well-known role, the lead in *Firebird*.

Joan Ganz Cooney felt that children could be educated by watching television. Founder and Executive Director of the Children's Television Workshop, she developed the idea and helped design the award-winning *Sesame Street*, which first aired in 1969. The show has been a successful children's television program ever since. She was also the mastermind behind *The Electric Company*, *321 Contact*, *Square One TV* and other children's programs.

GREAT AMERICAN WOMEN

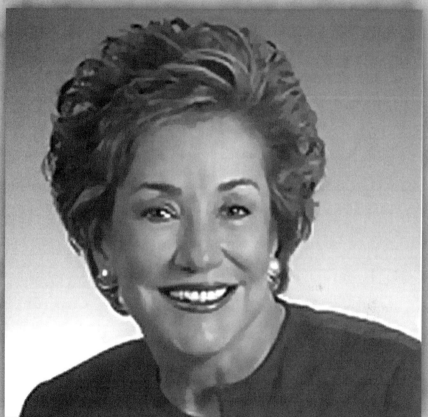

Senator Elizabeth Dole, courtesy of Senator Elizabeth Dole's office

SENATOR ELIZABETH DOLE

Reporters Hedda Hopper, Sheilah Graham and Luella Parsons were called the "unholy trio." They happened to be the first journalists to realize that Hollywood and its celebrities were news. These three women were despised, dreaded and essential to Hollywood. Louella Parsons wrote the first movie column ever in 1914.

Alice Paul, an ardent fighter for women's suffrage, organized one of the first major marches in Washington, D.C., in 1917. She founded the Women's National Party and drafted the Equal Rights Amendment (ERA) in 1923. Despite general opinion, the Equal Rights Amendment has not been ratified.

In 1962, along with Cesar Chavez, Dolores Huerta co-founded the United Farm Workers (UFW) union in California. She was inducted into the National Women's Hall of Fame in 1993 in recognition of her decades of work to secure safe and equitable treatment of farm workers. She is one of the most respected leaders in the labor movement.

Rosa Parks' name will forever be synonymous with the civil rights movement. In 1955 she refused to move to the back of a bus in Montgomery, Alabama, was arrested and fined. This resulted in the Montgomery bus boycott led by Martin Luther King, Jr. that continued for 381 days. That incident helped bring him to national prominence and marked a turning point in the fight for social change.

In 1987 Gayle Sierens was the first woman to do play-by-play broadcasts of National Football League games. She broadcast the Kansas City Chiefs and the Seattle Seahawks game on NBC.

In 1974 Barbara Rainey became the first female Navy pilot. She was given Wings of Gold, an award of distinction, and was later buried in Arlington Cemetery.

In 1930 Eleanor Medill Patterson became the first woman editor/publisher of a large metropolitan daily in the United States, *The Washington Herald*.

Several feminist publications emerged after the Civil War. *Revolution* was founded by Susan B. Anthony and Elizabeth Cady Stanton. In 1870 Lucy Stone, Mary Livermore and Julia Ward Howe edited the *Woman's Journal*, which was founded by the American Women's Suffrage Association, and ran until 1931 when it folded due to the Depression.

In 1915 Blanche and Alfred A. Knopf began their publishing company, Alfred A. Knopf, Inc. In 1921 Blanche became vice-president and director of the company. She brought authors like Thomas Mann, Sigmund Freud, Albert Camus, and Jean-Paul Sartre to the attention of the American public. The Knopfs published many Nobel Prize winning books.

In 1890 Rose Markward Knox, along with her husband Charles, created a business that promoted gelatin as a dessert. Knox Gelatin changed the public opinion of gelatin as a food just for sick people with widespread promotional and advertising campaigns about new uses and flavors for gelatin.

In 1922 Judith Cary Waller was the first station master of one of the earliest radio stations in the United States, WMAQ. It grew to be one of the largest stations in the nation under her direction.

WMAQ broadcast the first play-by-play baseball game from a home team ballpark. It ran the "Amos and Andy" show six nights a week in 1928—the first time that had been tried on radio. She was also a pioneer in educational radio. She later went on to win a George Peabody Award for "Ding Dong School," the first successful preschool TV program. The show aired on NBC from 1952 until 1956.

In 1975 attorney Margaret Bush Wilson was elected the first African-American female chairperson of the National Association for the Advancement of Colored People (NAACP). Wilson received much local, state and national recognition for her professional and civic work in assisting the African-American population in her hometown of St. Louis, Missouri.

The first woman television news anchorwoman was Dorothy Fuldheim. Ms. Fuldheim was still working at the age of 84 in 1977 at WEWS-TV in Cleveland, Ohio, capping a thirty year career in broadcasting.

Sioux City, Iowa's twin sisters, Esther Lederer and Pauline Phillips, better known as Ann Landers and Abigail Van Buren, began writing advice columns in daily newspapers (the *Chicago Sun Times* and the *San Francisco Chronicle*, respectively) on every topic under the sun in the mid 1950s. Their snappy, irreverent, but basically common sense, answers led to syndication and hundreds of millions of dedicated readers. Ann passed away in 2002 and Abigail is now known as Dear Abby, a column she still writes with the help of her daughter.

Gertrude Miller made designing child care products a career while at the same time increasing child safety. She invented the child mini- toilet seat ("toidy seat"), the safety auto seat ("infant and child car seat") and the folding booster seat.

In 1964 Hazel Brannon Smith was the first woman ever to receive the Pulitzer Prize for editorial writing. She was the owner of four weekly newspapers in rural Mississippi, and her editorial column "Through Hazel Eyes" kept a watchful eye on social order, injustice and local politics. Hazel was an avid Civil Rights activist and her offices and home were often under attack, but she remained committed to spreading truth and justice through her press and voice.

In 1918 Kathryn Sellers was nominated by President Woodrow Wilson as head judge of the juvenile court in Washington, D.C., making her the first woman to be in charge of a juvenile court.

In 1922 Rebecca Latimer Felton was the first and oldest woman, at age 87, to serve in the United States Senate. Ms. Felton took over an unexpired Senate term, and she was appointed by Georgia governor, Thomas Hardwick, who had opposed the suffrage movement.

Irene Corbally Kuhn worked and traveled throughout the world, as a broadcaster, journalist, war correspondent and novelist. In 1920 she was one of the first female reporters to fly for a story. She was also one of the first woman to broadcast in the Orient and the first woman to broadcast from a Navy vessel during World War II.

In 1886 Harriet Hubbard Ayer was the first woman to establish a major cosmetics company. She was a pioneer in modern merchandising, using the newspaper to advertise her line of products. She was first known for her face cream, but went on to write an advice column for *New York World* from 1896-1903, and wrote a best seller, *A Complete and Authentic Treatise on the Laws of Health and Beauty*.

In the 1920s Ida Cohen Rosenthal designed the Rosenthal Brassiere and developed the Maidenform Company. Her design was the first to use cups to support the breasts and the first to come in a variety of sizes.

In 1937 reporter Anne O'Hare McCormick became the first woman to be awarded a Pulitzer Prize in journalism for foreign correspondence. She was a respected authority on international affairs. *The New York Times* called McCormick "the expert the experts looked up to."

Elizabeth Arden, who was born Florence Nightingale Graham, created and developed a multi-million dollar cosmetic corporation, Elizabeth Arden Cosmetics. Ms. Arden was instrumental in changing the image of cosmetics from use by only "cheap women" to use by "respectable" American women. Elizabeth Arden started the American Beauty Industry by selling face cream, perfume, makeup, clothing and operating salons. When she died in 1966, the Elizabeth Arden Company was grossing and estimated $60 million per year, with over 100 Elizabeth Arden beauty salons throughout the world, and the Elizabeth Arden Corporation manufacturing and selling close to 300 products.

In 1917 Western Union hired their first messenger girls.

In 1919 Lena Madeson Phillips developed the first business group for women, the National Federation of Business and Professional Women's Clubs, Inc., now known as BPW.

At the time of her death in 1916, financier Hetty Green was considered "the richest woman in the world" with a fortune of $100 million. A frugal investor with an unpleasant disposition, Mrs. Green was often referred to as the "Witch of Wall Street."

The All American Girls Professional Baseball League (AAGP-BL) was started in 1943 by chewing gum mogul, Philip Wrigley, to give fans something to watch during World War II. The movie, *A League of Their Own*, dramatized its early years. The league folded in 1954.

In 1973 Lieutenant Jane McWilliams and Lieutenant Victoria Vogue received their Wings of Gold, making them the first women flight surgeons in the Navy.

In 1865 Dr. Mary Walker became the first woman ever to receive the Medal of Honor for her work as a medical officer during the Civil War. Mary was a surgeon assisting both Union and Confederate soldiers, but was a spy for the Union. Mary often took federal supplies and went to help the poor and war damaged women and children of Georgia and Tennessee. Although married, Mary kept her maiden name and is known for her contribution to women's rights and humanitarian and medical treatment.

In 1917 Loretta Walsh was the first female to join the U.S. Navy and, reportedly, the first to ever enter a naval armed service.

Edith Head had a distinguished fashion design career in Hollywood. Ms. Head designed costumes for over 500 films and was the first woman to manage a design department of a major film studio, Paramount Studios, in 1938. By 1976 she had won eight Academy Awards and received thirty-three nominations for best costume design.

Eleanor Roosevelt, courtesy of the Library of Congress

ELEANOR ROOSEVELT

African-American journalist and teacher, Ida Bell Wells-Barnett, was a crusader in exposing the lynching of black men in the South in 1892. She used her newspaper, *The Free Speech*, to print the findings of her investigations of these hangings. After her office was destroyed while she was visiting in the North, she decided not to return to her newspaper or to the South and married and settled in Chicago.

Women in the Air Force (WAF) was created in 1948, with Colonel Geraldine P. May as its first director.

In 1966 former teacher, Margaret McNamara, founded Reading is FUNdamental (RIF) in Washington, D.C. As a teacher-aide, she found that children became successful readers when provided with books of their own choosing.

In 1925 Margaret Cuthbert began her illustrious career in radio at WEAF (later changed to WNBC). She won a Peabody Award for *NBC Theatre*.

In 1941 Mary Shotwell Ingraham founded the United Service Organizations (USO) to provide a safe place for soldiers away from home. Ingraham also served on a committee of the U.S. War Department which chose the first women officers for training in the Women's Auxiliary Army Corps. Mary also served for the YWCA as president of the Brooklyn YWCA from 1922 to 1939 and then as president of the national board for five years. Mary was also active with the New York City Board of Higher Education for thirty years, serving without pay.

Tara Lipinski became the youngest figure skater champion, at age 15, to win Olympic gold in 1998.

In 1923 author Edna St. Vincent Millay became the first woman to receive a Pulitzer Prize for poetry for her book, *The Ballad of the Harp-Weaver*.

Women were able to join the U.S. Merchant Marine Academy in 1974.

In 1778 during the Revolutionary War, Mary McCauley carried pitchers of water to soldiers at the battle of Monmouth. Her fame spread and she was nicknamed "Molly Pitcher." During the war, McCauley took care of the kitchen, laundry and other tasks in the Army camp. Her tireless work was acknowledged in 1822 when she became the first woman to receive an annual military pension.

Dr. Gerty Cori in 1947 was the first woman doctor to win a Nobel Prize. She won the prize with her husband, Dr. Carl Cori, for physiology and medicine, which laid the foundation for discovering how cells process food and convert it to energy.

In 1961 Marianne Means became the first female journalist assigned to the White House. The Phi Beta Kappa University of Nebraska graduate covered the White House from 1961 to 1965, then went on to earn a law degree from George Washington University Law Center. She published *The Woman in the White House* while assigned there.

Deborah Sampson represented herself as a man in 1782 so she could enlist and fight in the Revolutionary War. She was discovered a year later when she had to be hospitalized and was discharged from the Army.

Women were permitted to enter the White House Police Force in 1970.

Senda Berenson developed the first official rules for women's basketball in 1899. Basketball was first played by women in 1892 at Smith College.

The all male Golden Gloves boxing tournament became mixed in 1975 when 23-year-old Marion Bermudez became the first woman to compete in a tournament.

In 1957 Jacqueline Bernard co-founded (with Jim Gyleson) Parents Without Partners, a support organization for divorced or widowed parents.

Helene Britton was the first woman owner of a major league ball team, the St. Louis Cardinals, from 1911-1917.

California attorney Carla Anderson, at the age of 28, achieved two of the highest positions ever held by a woman in government. In 1974 she was appointed assistant Attorney General in the Justice Department's Civil Division, managing over 250 Justice Department lawyers in Washington, D.C. In 1975 she became Secretary of Housing and Development in the cabinet of President Gerald Ford, making her the third woman to hold a cabinet position in American history.

Elizabeth Dole has had a distinguished career in the public arena. A few of her many accomplishments are as commissioner of the Federal Trade Commission from 1973-1979; Secretary of Transportation, 1983-1987; Secretary of Labor, 1989-1990; president of the American Red Cross, 1990-1998; and is now a Senator from North Carolina.

In 1975 Helen Thomas of the United Press International was the first woman to be elected president of the White House Correspondents Association, first to be elected to the distinguished Gridiron Club and first to open and close a presidential news conference.

"Blazin" Bertha Tickey, in 1953, pitched an all-time record for the most strikeouts in a single game of softball—20. She was the only player to compete with 11 National Championship teams.

At the 1960 Olympics, Wilma Rudolph became the first woman to win three gold medals in track and field events, winning the 100-meter sprint (11.0 seconds), the 200-meter dash (24.0 seconds) and 4 X 100-meter team relay (44.5 seconds combined time). The St. Bethlehem, Tennessee, native was named Associated Press Athlete of the Year in 1960 and 1961. She overcame many childhood illnesses and physical disabilities on her way to becoming an outstanding runner.

In 1984 Joan Benoit was the first woman to win an Olympic marathon.

Mary L. Peterman received the Sloan Award in cancer research and became the first woman member of the Sloan Kettering Institute for Cancer Research in 1963.

In 1917 one hundred women participated in the first sanctioned women's bowling tournament in St. Louis, Missouri.

In 1977 Lise Ann Russell, at age 14, became the youngest amateur to compete in a Ladies Professional Golfers Association (LPGA) event.

In 1972 Lin Bolen broke new ground for women in broadcasting management by becoming the first woman to manage daytime programming at a major television network (NBC). She expanded soap operas from thirty minutes to one hour and was responsible for increasing the cash prizes on game shows.

In 1970 Colonel Anna M. Hays was given a promotion no other woman had ever received. She became a Brigadier General and the first woman in the history of the U. S. Army to be promoted to the rank of general officer.

In 1949 President Harry Truman appointed Mississippi native Burnita Matthews to serve as a federal district judge, making her the first female ever to hold this position.

Massachusetts Astronomer Maria Mitchell discovered a new comet in 1847 which was named for her, Miss Mitchell's Comet. The next year she was asked to join the American Academy of Arts and Sciences, making her the first woman to join this organization.

Eugenie Moore Anderson was the first American female appointed as ambassador of a foreign country. She was nominated by President Harry S. Truman and served in Denmark from 1949—1953.

In 1931 author Pearl Buck received a Pulitzer Prize for *The Good Earth* and, in 1938, was the first U.S. woman to be awarded a Nobel Prize for Literature.

Broadcast Journalist Barbara Walters was the first woman ever to co-anchor an evening network news program in 1976. She partnered with Harry Reasoner on the "ABC Evening News." That same year she also began hosting "The Barbara Walters Special." She has been co-host of ABC's "20/20" since 1979 and has received many honors and awards, including an Emmy in 1975. Walters retired on September 17, 2004, stating she will occasionally do special interviews.

In 1970 Kathy Rigby was the first ever U.S. gymnast to win a medal at the World Gymnastics Championships. She was awarded a silver medal for balance beam. Rigby is a two time Olympian and a Broadway entertainer, nominated for the Best Actress Tony Award in 1991 for her famous role as Peter Pan.

The first female Brigadier General in the history of the Marine Corps was Colonel Margaret Brewer, who received her promotion in 1978.

In 1978 Mary Clarke was the first woman to become a major general in the U.S. Army.

Natalie Dunn won her first roller skating event when she was seven, and went on to win the world title in figure roller skating in 1976 when she was 20.

At the 1952 Olympics, Andrea Mead Lawrence won a gold medal for women's giant slalom skiing and a gold for slalom. This was the first year this event was admitted in Olympic competition. She became the first ever U.S. skier to win two gold medals for skiing.

In 1924 Ora Washington was the first African-American Woman to win the American Tennis Association singles title.

Mildred "Babe" Didrikson Zaharias was one of the greatest U.S. athletes. Mrs. Zaharias won awards in basketball, track and field, figure skating and golf. She won three gold medals and set three world records (for javelin throw, 80-meter hurdles and high jump) in the 1932 Olympic games. Mrs. Zaharias won every available golf title from 1940 to 1950, including the World and National Opens.

Margaret "Midge" Costanza was the first woman to hold the title of Assistant to the President in Jimmy Carter's administration.

17-year-old diver Jennifer Chandler won a gold medal at the 1976 Summer Olympics. Her score for the ten required dives added up to the most points ever scored by a woman.

In 1950 journalist Geri Joseph was the first woman to win the Sigma Delta Chi Journalism Award. During her career she also received five American Newspaper Guild awards.

Joyce Hoffman was a pioneer of women's surfing. Not only did she dominate Women's surfing in the mid 1960's, but in 1966 she won her second consecutive World Surfing Championship. Hoffman is one of eight original inductees into the International Surfing Hall of Fame.

Helen Keller never let her blindness and deafness be obstacles to living a full and accomplished life. She received a Bachelor of Arts degree with honors from Radcliffe College in 1904. She helped to found the Massachusetts Commission for the Blind and raised more money for the American Foundation for the Blind than any other person. Many honors and awards were bestowed upon her by foreign governments and international organizations.

Sheila Young is the first athlete to become world champion in two different sports. She won the 1975 World Sprint Championship in speed skating and, in 1976, won the National Bicycle Track Championship.

GREAT AMERICAN WOMEN

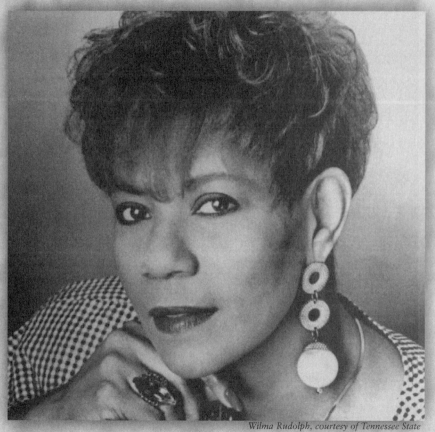

Wilma Rudolph, courtesy of Tennessee State

WILMA RUDOLPH

Lila Cheson Wallace, with her husband, founded *Reader's Digest* in 1922. Jointly, Lila and Dewitt Wallace built *Reader's Digest* into one of the most widely-circulated magazines.

Women were able to join the U.S. Air Force Academy as cadets in 1976. That same year, they were also allowed to join the U.S. Coast Guard Academy and the U.S. Military Academy.

In 1926 Gertrude Ederle of New York City became the first woman to swim the English Channel. It took her 14 hours and 31 minutes to swim the waterway. A stormy day and turbulent water made the usual 21-mile trip into the 35-mile swim of her life. And even at that, her time was nearly two hours better than any man had ever done. She was given a ticker-tape parade in New York City, cheered by millions of people, upon her return.

In 1976, at age 19, Laure Connelly was the youngest licensed trainer in thoroughbred racing.

Margaret Mitchell is probably the most famous one-novel author. *Gone With the Wind* took her 10 years to complete and, before she died in 1949, it had sold over eight million copies and won her a Pulitzer Prize. Next to the Bible, *Gone With the Wind* has been the biggest, best-seller ever.

In 1972 Jean Westwood was the first United States woman to chair a national political party, the Democratic National Committee, and managed the presidential campaign for Senator George McGovern that same year.

In 1966 Stephanie Kwolek's work in chemical compounds at DuPont led to the development of a synthetic material known as Kevlar which is five times stronger than the same weight of steel. Kevlar has been used in bulletproof vests, underwater cables, brake linings, space vehicles and more.

The first patent granted to a woman in the United States was in 1793 to Mrs. Samuel Slater for cotton sewing thread.

In 1876 artist Mary Cassatt's work was shown at the Philadelphia Academy of the Fine Arts Show and introduced the U.S. to Impressionist painting. She is best known for her portraits of mothers and children.

Pilot Jacqueline Cochran, in 1948, was the first woman to break the sound barrier (exceed the speed of sound). Ms. Cochran held more air speed records than any other woman at that time.

In the Lindberg family it wasn't just Charles who was a pilot. In 1930 his wife, Anne Morrow, qualified for a glider's license, making her the first woman to accomplish this feat. In 1934 the National Geographic Society presented Mrs. Lindberg with the Hubbard Gold Medal.

In 1879 Mary Mahoney became the first African-American nurse in the United States. A graduate of the New England Hospital for Women and Children, she was one of three people to complete the 16-month program.

Magazine illustrator and doll designer Rose Cecil O'Neill made millions in royalties after her "Kewpies" were published in *The Ladies Home Journal* in 1907. The small, chubby dolls with a top-knot of hair caught the imagination of America and turned up as salt and pepper shakers, stationery, buttons, etc.

Because of the tireless lobbying efforts of Alice Lakey of Cranford, New Jersey, the Pure Food and Drug Act was passed in 1906. Ms. Lackey was concerned about what was in the food she ate. She organized women's clubs in the United States to write letters, and she went across the country presenting a display of contaminated foods. In 1905 Ms. Lakey and five other people were able to persuade President Roosevelt to support the bill.

Alberta Hunter was a significant influence on blues music. Not only was she an early recorder of blues in the 20s, but she was also a song writer. She is credited with introducing blues music to Europe.

In 1962 Barbara Wertheim Tuchman became the first woman to receive the Pulitzer Prize for general nonfiction for her book, *The Guns of August*. She accepted her second Pulitzer in 1972, also for general nonfiction (*Stillwell and the American Experience in China*). Tuchman was the first woman president of the American Academy and Institute of Arts and Letters in 1979.

In 1985 Libby Riddles became the first woman to win the Iditarod Trail Sled Dog Race. It was the third time she had completed the grueling 1,100+ mile race. Using 13 dogs, she finished in just over seventeen days. Another woman, Susan Butcher, won the race four out of the next five years.

In 1977 14-year-old Tracy Austin became the youngest competitor ever allowed to play tennis at Wimbledon. At age 29 she was the youngest player ever to be inducted in the Tennis Hall of fame and was ranked number one. She holds 30 total career titles and two Grand Slam titles.

In 1916 sisters Adeline and Augusta Van Buren became the first women to ride across America on motorcycles. Their 5,500 mile, sixty day trip was made to convince the U.S. government that women were capable of serving in the armed forces. (Adeline was later rejected when she volunteered for the Army.)

In 1970 Ada Louise Huxtable, member of *The New York Times* editorial board and architecture critic, received the first Pulitzer Prize awarded for distinguished criticism. She wrote with passion about misguided urban renewal efforts and was instrumental in preserving the New York Customs House and the St. Louis Post Office.

Lady Bird Johnson was born Claudia Alta Taylor. Her nurse once said that she was "as purty as a lady bird," and the nickname was born. Her interest in environmentalism led her to get thousands of tulips and daffodils planted in Washington, D.C. when she was the First Lady. And, the Highway Beautification Act of 1965 was the result of her national campaign for beautification.

In the early 1900s, Lane Bryant was the first woman to design and make maternity clothes. Her designs were such a big hit that, by 1917, her firm had done a million dollars worth of business in maternity clothes. The Lane Bryant stores are now known for selling clothes to "fuller figure" women.

In 1932 Marian Underhill became the first American woman to climb the Matterhorn. She climbed it with Alice Damesme, a European climber.

In 1981 Elizabeth Jones became the first woman, and eleventh person, to be chief sculptor-engraver of the U.S. Mint.

Helen Gurley Brown became a best-selling author with *Sex and the Single Girl* in 1962. Considered revolutionary in its time, the book offered advice on love, sex and lifestyle for the single woman. In 1965 she became editor in chief of *Cosmopolitan* magazine and boosted its sales dramatically, continuing to provide advice to women.

Louise Bethune became the first woman selected to be a member of the American Association of Architects in 1888. She designed 18 schools in New York, as well as banks, factories and housing developments. She was responsible for building a music store that was one of the first constructed with a steel frame and poured-concrete slabs.

In 1879 Massachusetts native, Mary Baker Eddy, founded the Church of Christ, Scientist. Inspired by a scripture healing during an illness, she began her ministry with the understanding that pain can be healed through the inspired mind. When Eddy died in 1910, an estate of more than two million dollars was left.

At age 87, in 1970, Imogen Cunningham was elected to the American Academy of Arts and Sciences and received a Guggenheim fellowship in photography. Working for over 70 years at her craft, she had the longest career in American photography at that time.

The first African-American singer to have a leading role in a Metropolitan Opera premiere was Leontyne Price in 1966. She was touted as the finest Aida of her day (1958-60) by European and American audiences.

In 1975 Margaret Mead and Frederica De Laguna became the first female anthropologists asked to be members of the National Academy of Sciences.

Nancy Dickerson became the first female television correspondent at CBS in 1960. In 1963 Ms. Dickerson became the first and only female to have a daily network television news program on NBC.

Dinah Shore, from Nashville, Tennessee, whose real name was Fanny Rose Shore, was one of the most celebrated singers of the 1940s and 1950s. Ms. Shore had her own radio shows and entertained soldiers overseas during World War II. In the 1950s her television program became an overnight success.

In 1925 country performer Maybelle Addington Carter created a style of playing the guitar which changed the guitar from just a rhythm instrument to a lead instrument. This is called the "Carter lick." She was one of the members of the musical Carter family and the mother of June Carter Cash.

In 1937 songwriter Dorothy Fields won an Oscar for songwriting, making her the first woman to receive such an award. Dorothy was a famed Broadway songwriter, acclaimed with hits such as "The Way You Look Tonight," "The Sunny Side of the Street," and "I'm in the Mood for Love."

In 1968 Kathy Kusner became the first licensed woman jockey in the U.S. This marked a turning point in the acceptance of women as equal competitors in the world of horse racing.

In 1914 Helen Balliser was one of the first women to serve as an ambulance doctor. Dr. Balliser worked for Bellevue Hospital in New York City.

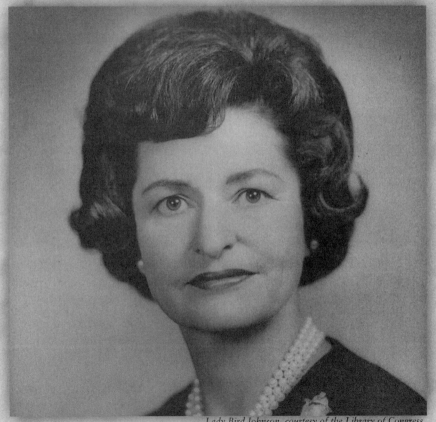

Lady Bird Johnson, courtesy of the Library of Congress

LADY BIRD JOHNSON

In 1895 architect Marion Mahony Griffin became one of famed architect Frank Lloyd Wright's first assistants. Ms. Griffin had a great deal to do with the success of the Wasmuth Portfolio, which showcased Wright's talents to the world.

Mae Jemison holds degrees in Chemical Engineering and Afro-American studies, is a medical doctor, and, as a former astronaut, was the first African-American woman in space. She is currently director of the Jemison Institute, an organization she founded to advance the use of technology in developing countries.

In 1983 Ellen Zwilich became the first woman to receive a Pulitzer Prize for music. Zwilich's award winning *Symphony 1* gained her recognition world wide. She has composed numerous astonishing pieces and received numerous awards. Her accomplishments include first Composer's Chair in the history of Carnegie Hall in 1995, Musical America's Composer of the Year in 1999 and induction into the American Academy of Arts and Letters.

In 1932 dancer and choreographer Martha Graham was the first dancer to be honored with a Guggenheim Fellowship. She was a pioneer in bringing modern dance before audiences and formed her own school and company. She choreographed over 160 ballets.

In 1933 Ruth Wakefield created the chocolate chip cookie. She and her husband owned a tourist lodge called the Toll House Inn where she gained local notoriety for her desserts. Using bits made from a semi-sweet chocolate bar given to her by Andrew Nestlé, her Butter Drop Do cookies became the perennial favorite Toll House cookies.

In 1934 author Katherine Anne Porter, great-great-great-granddaughter of Daniel Boone, published her first short story. Many other stories, a full length novel and awards followed, including a 1966 Pulitzer Prize and National Book Award for *The Collected Short Stories of Katherine Anne Porter*.

In 1941 Oveta Culp Hobby became the first director of the Women's Army Auxiliary Corps (WAAC). In 1945 under her skilled direction, the Women's Army Corps (which changed its name to WAC in 1943) had 99,000 women serving in the U.S. and abroad.

Tennis star Billie Jean King will go down in history as the first woman to win the most Wimbledon titles—19. She won six singles, nine doubles and four mixed doubles from 1961 to 1975. In 1962 she was named Outstanding Female Athlete of the World and in 1972 she was the first female to be honored as *Sports Illustrated's* Sportsperson of the Year. Ms. King's other claim to fame is that she is the first female athlete to win over $100,000 in a single season. Today Ms. King is an advocate for women athletes receiving equal pay as men and a popular television commentator.

In 1921 Margaret Gorman was the first to be crowned Miss America. She is also the youngest ever to be crowned at age 15.

In 1920 Florence Allen became the first woman to sit on any general court and the first woman to sit on the U.S. Court of Appeals in 1934. In Ohio she was the first woman to preside at a first-degree murder trial and the first woman to sentence a convicted felon to the death penalty.

In 1869 Susan B. Anthony took charge as the chairwoman of the executive committee of the National Woman Suffrage Association and, in 1892, was elected its president. Ms. Anthony's life-long ambition was to fight for women's rights and the right for women to vote. She created the foundation for the 19th amendment, which was voted into law on August 18, 1920. Unfortunately, Ms. Anthony did not live to see the day when women could vote. She died in 1906. In 1979 she became the first American woman to be represented on a coin.

The first U.S. woman to direct films was Lois Weber who directed and co-starred in many silent films. In 1913 Ms. Weber became the mayor of Hollywood's Universal City.

In 1905 May Sutton Bundy was the first woman to win the women's singles title at the Wimbledon Tennis Championships.

In 1977 Eva Shain became the first woman to judge a world heavyweight fight. Ms. Shain judged the Muhammed Ali vs. Ernie Shavers fight.

In 1947 director Antoinette Perry became the first woman to have an award named after her, The American Theatre Wing Institute Antoinette Perry Award. The name of the award has been shortened to Ms. Perry's nickname, the Tony Award.

In 1975 *The New York Times'* sports reporter, Robin Herman, became one of the first two female journalists invited by the team coaches to interview the male players in their dressing rooms. She and Canadian radio reporter, Marcelle St. Cyr, interviewed players (who were not notified of their visit in advance) at the National Hockey League all-star game in Montreal.

Actress Mary Pickford made over two hundred silent films plus four "talkies," and, in 1932, was one of the wealthiest self-made women in the U.S. In 1932 her wealth was calculated to be around $50 million.

In 1896 Mary Irwin kissed John Rice in the film, *The Kiss*. This made her the first actress in a film to share a kiss.

In 1949 children's' entertainer, Shirley Dinsdale, was the first woman to win an Emmy Award for "most outstanding television personality." She trained with famous ventriloquist Edgar Bergen and went on to star in her own puppet show, "Judy Splinters."

Janet Gaynor won the Academy Award for best actress in 1927/1928 for three movies, *Seventh Heaven*, *Sunrise, and Street Angel*. In the beginning, the Academy Awards were given for cumulative work. By 1934, Gaynor was the top female box-office star in America.

In 1973, at age 15, Lynn Cox swam the English Channel from England to France in nine hours and thirty-six minutes, breaking the male and female records. In 1987, Cox was the first person to successfully swim the Bering Strait, which separates Alaska and Russia, in water temperatures of 38-42 degrees Fahrenheit. Cox used her swimming to bring nations together and promote peace, as seen in her 1988 swim from the USA to USSR, which helped bring the United States and Soviet Union together. It was also one of the coldest swims ever recorded.

Playwright Lorraine Hansberry achieved two important firsts. In 1959 her play, *A Raisin in the Sun,* was the first one written by an African-American female to be performed on Broadway. She was also the first African-American woman to receive the New York Drama Critics Circle Award.

In 1981 Arizona native, Sandra Day O'Connor, became the first female judge appointed to the United States Supreme Court. She was selected by President Ronald Reagan.

Multi-talented Maya Angelou, born in 1928 in St. Louis, is a popular author of books, plays, poems and has been a professional performer and songwriter. Ms. Angelou has had 12 best sellers and is the first African-American woman to have a movie script produced. Ms. Angelou was also the inaugural poet for President Bill Clinton in 1994, is a Civil Rights Activist, and in 1981 was appointed to a lifetime professorship for American Studies at Wake Forest.

In 1976 Alice Mitchell Rivlin was named director of the newly created Congressional Budget Office.

Writer Edith Wharton was the first woman to win two Pulitzer Prizes. She received her first one for *The Age of Innocence* in 1920 and the second for *The Old Maid* in 1935. Ms. Wharton also was the first woman to be given an honorary doctorate from Yale University. At the time of her death in 1937, she had been given more honors than any other female American writer.

Harriot Hunt, in 1835, became the first female to practice medicine in America. In 1833 Ms. Hunt began medical studies with a physician. She and her sister opened a clinic for women and children in 1835. She was admitted to Harvard Medical School in 1850; but riots by male medical students broke out, and she was forced to leave Harvard. She was awarded an honorary degree in 1853 from the Female Medical College of Pennsylvania.

Author Gertrude Stein wrote many books and befriended the famous such as Matisse, Picasso, Hemingway, and Faulkner; but, she is probably most famous for the statement, "A rose is a rose is a rose."

In 1812 Ann Judson and Harriett Newell were the first women to become overseas missionaries. They went to India to convert Indians to Christianity. That same year, Ms. Newell became the first American female missionary to die in a foreign country.

Alicia Patterson and her husband, Harry Guggenheim, founded *Newsday* in 1940. This newspaper grew to be one of the most successful suburban dailies in the United States.

Author Margaret Leech became the only woman to receive the Pulitzer Prize for history, two times, first in 1942 for *Reveille in Washington*, and then in 1960 for *In the Days of McKinley*.

In 1959 journalist Marie Torre was the first newspaper woman jailed for contempt-of-court in the Hudson County, New Jersey, women's prison for declining to name a news source. Torre spent ten days in jail for refusing to divulge the name of the CBS executive who made derogatory comments about Judy Garland, which resulted in a libel suit against CBS. Citing the First Amendment as her defense, she was called the "Joan of Arc of her profession" by the judge who sentenced her.

In 1866 Lucretia Mott was the first president of the American Equal Rights Association.

In 1924 Margaret Petherbridge Farrar became the first woman to produce a crossword puzzle book; and, in 1942, Ms. Farrar was the first woman to edit *The New York Times'* crossword puzzles.

Pauline Frederick broke ground for female broadcasters in 1948 by becoming the first female network broadcast journalist to report on national political conventions for television. After that breakthrough, she was the only female broadcaster to report hard news on network radio and television for the next 12 years. She was the first woman to win the DuPont Commentator's Award in 1954 and also won the Peabody Award in 1955.

In 1930 Frances Marion received an Academy Award for writing *The Big House*, making her the first woman ever to receive an Oscar for this category. She won again in 1931 for *The Champ*. Over 136 of her screenplays were produced in her lifetime, seventy of which were westerns.

In 1986 Nancy Lieberman became the first woman athlete to play basketball in a men's professional league, playing with the Long Island Knights and the Washington Generals. Lieberman is a broadcaster for ESPN, runs basketball camps for youth, and a coach of the Dallas Fury in the National Women's Basketball League.

Country singer and song writer Dottie West was the first female vocalist to win a country music Grammy award. She wrote more than 400 songs. *"Stand By Your Man"* was voted the #1 country song of all-time.

Emily Dickinson's first poem, *The Valentine,* was published in 1852. She is considered one of the two most gifted poets in American literature, along with Walt Whitman. Only six of her poems were published in her lifetime.

In 1969 women were allowed, for the first time, membership into Sigma Delta Chi, the fraternity for journalists.

Maybelle Carter, courtesy of Peggy Knight

MAYBELLE CARTER

In 1893 English teacher and author Katharine Lee Bates and five others went on a wagon trip up to Pikes Peak. After stepping from the wagon, Ms. Bates glanced at the spectacular view for the first time and a poetic line came to her, "Oh, beautiful for spacious skies, for amber waves of grain." Back in her hotel, she wrote the rest of the poem which she titled *"America The Beautiful."* Ms. Bates kept the poem until 1895, then sent it to the *Congregationalist*, a religious magazine. They published it on July 4, 1895. Ms. Bates decided to set her poem to music and picked the hymn *"O, Mother Dear, Jerusalem."* The rest is history.

Dorothy Azner was a creative film director. She was the first female director of "talking" films, and she was the first to develop the concept of an overhead microphone.

The Women's Professional Football League was developed in 1974. It was made up of seven teams and each player made $25 per game.

In 1932 Dr. Elize L'Esperance established the first clinic in the United States for the detection of cancer. She was on the faculty at Cornell Medical School for 40 years; and, in 1950, she became the first woman to hold a full professorship there.

Jane Addams, in 1931, was the first woman to win the Nobel Peace Prize. Her life-long goals were to work for women's suffrage and for peace. In 1889 Ms. Addams and Ellen Gates Starr founded a center where there could be a system of dispensing an assortment of different community services through one main area. This resulted in the developing of Chicago's famed Hull House. Many laws, rules and regulations were enacted because of Ms. Addams work with the poor. Ms. Adams co-founded the Women's International League for Peace and Freedom in 1915. And, in 1920, Ms. Addams was one of the originators of the American Civil Liberties Union (ACLU).

In 1955 Dr. Ethel Percy Andrus founded the American Association of Retired Persons (AARP).

During World War II, the members of the Women's Air Force Service Pilots (WASPs) went through training similar to their male counterparts. They endured officers' training, lived in barracks, had to obey military discipline and wore GI uniforms. From 1942—1944, over 1,000 women were approved to join the WASPs.

In 1942 Helen McAfee was sworn in as lieutenant commander of the newly created Women Accepted for Volunteer Emergency Services (WAVES).

In 1915 Emily Greene Balch co-founded the Women's International League for Peace and Freedom. Working most of her life for peace and human rights, she won the Nobel Peace Prize in 1946 for her involvement with the League.

In 1924 Caroline Smith became the first woman to win a gold medal for Olympic platform diving. This was the first time platform diving was held at an Olympic game.

In 1971 President Richard Nixon appointed Laurie Anderson, Sue Baker, Kathryn Clar, Holly Hofschmidt and Phyllis Shants as the first female Secret Service Agents.

Aviation great Amelia Earhart achieved many firsts. She was the first woman to be a transatlantic plane passenger (1928); the first woman to make a solo transcontinental round trip flight (1928); and, in 1932, she was the first woman to fly solo across the Atlantic Ocean.

In 1965 Vivian Malone endured harassment and prejudice to become the first African-American to graduate from the University of Alabama.

One of the hardest working and innovative first ladies was Eleanor Roosevelt. Mrs. Roosevelt was a crusader for human rights and was the first, first lady to hold a news conference attended only by female reporters. Mrs. Roosevelt also wrote four books.

In 1927 Elsie Eaves became the first woman member of the American Society of Civil Engineers and the American Association of Cost Engineers. She was also the first female life member of the National Society of Professional Engineers.

Carry Amelia Moore Nation made herself, and the temperance movement, famous in the 1890s by bursting into saloons and bars, singing hymns and swinging a hatchet at bars and tables.

Margaret Higgins Sanger was a crusader for birth control. In 1913 she familiarized women with the term "birth control" through her publication, *The Woman Rebel*. She was arrested and charged with distributing "obscene" literature through the mails. Shortly after this, Ms. Sanger started a birth control clinic on the Lower East Side of New York City and was arrested and spent a month in prison. Her American Birth Control League later became known as the Planned Parenthood Federation.

In 1970 Margaret Kuhn founded the senior citizens activist group, The Gray Panthers.

In 1876 Anna Bissell, and her husband Melville, invented the carpet sweeper and called it the "Bissell."

In 1951 Marguerite Higgins became the first woman to win the Pulitzer Prize for international reporting, covering the "police action" in Korea. She also covered the liberation of the concentration camp at Dachau and the Nuremberg trials during World War II.

Lyricist Betty Comden has had an impressive career. She and her partner, Adolph Green, wrote songs together beginning in the late 1930s. Their music has been heard in the theatre and in the movies. They wrote *"On the Town"*, *"Billion Dollar Baby,"* *"Two on the Aisle,"* *"Wonderful Town,"* the screen-play *Auntie Mame* and the script and lyrics for *Singin' in the Rain*.

In 2004, Phylicia Rashad became the first African-American to win a Tony Award for her leading role in *A Raisin in the Sun*.

In 1871 Marilla Ricker was the first woman to vote. Her ballot was refused, but her vote was accepted.

In 1869 two suffrage organizations were formed. Susan B. Anthony and Elizabeth Cady Stanton founded the National Woman Suffrage Association. This organization was formed primarily to lobby for the passage of an amendment giving the vote to women. The American Woman Suffrage Association was developed by Lucy Stone and Julia Ward Howe. This association wanted the vote for women, but they also were active in giving the vote to black men. For many years these two groups were at odds with each other; but, in 1890, they combined their forces to form the National American Women Suffrage Association. In 1920 when the 19th amendment was ratified, the League of Women Voters became the replacement organization.

Choreographer and dancer Katherine Dunham used her expertise and Ph.D. in anthropology to study African-American dance. Her technique made her an innovative choreographer of African- American dance. She worked with the Works Project Administration in the 1930s on a Chicago dance project. *Cabin in the Sky*, her most famous Broadway musical, opened in 1940.

Martha Washington, in addition to being married to the first president of the United States, was the first woman to have her picture on U.S. paper money (1888) and, in 1902, the first woman to have her picture on a postage stamp.

The National Weather Service first started using female names for hurricanes on May 25, 1953. The first hurricane was named Alice. Male names were added in 1979.

In 1976 Sarah Caldwell became the first woman to conduct the Metropolitan Opera.

Journalist and author Erma Bombeck made living in the suburbs a funny experience. Bombeck's column, *At Wit's End,* was enjoyed by tens of millions of readers and was syndicated in more than 800 newspapers before her death in 1996. She was also a very successful book author. In 1973 she received the Mark Twain Award given to the top humorist in the country.

In 1978 Marcy Schwam was the first woman to run up the stairs of the Empire State Building in New York City's first annual run-up. She made it to the observation deck on the 86th floor in 16 minutes, 3.2 seconds, climbing the 1,575 steps to place 10th.

The Baby Ruth candy bar was named for Ruth Cleveland, daughter of President Grover Cleveland. Not the famed baseball Hall of Famer, Babe Ruth.

Georgia Clark was the first female treasurer of the United States. She was appointed by President Harry S. Truman in 1949.

June Carter Cash was taught by her mother, Maybelle Carter, to play the autoharp. In 1937 June started performing with her sisters as the Carter Sisters. In addition to singing, June was an accomplished actress, comedienne and songwriter, co-writing the hit song Ring of Fire, which her husband Johnny Cash recorded.

In 1932 Marian Cummings became the first woman to receive a commercial pilot's license. She piloted a corporate plane for her husband's New York City law firm.

Born into slavery, Sojourner Truth (Isabella Baumfree) obtained her freedom and challenged injustice wherever she found it. She was an abolitionist, women's rights activist and preacher. She fought for desegregation of public transportation in Washington, D.C., during the Civil War.

Ella Tambussi Grasso was the first female in the U.S. to win an election for governor who did not follow her husband into office. On January 8, 1975, she became governor of Connecticut.

Dr. Elizabeth Blackwell, courtesy of the Library of Congress

DR. ELIZABETH BLACKWELL

In 1977 Indiana resident, Jacqueline Means, was the first woman to be ordained with the official sanction of the Episcopal Church in the U.S.A. Reverend Means is married and the mother of four.

Widely recognized as the best all-around women's soccer player, Mia Hamm led her team to gold at the Centennial Olympic Games in Georgia in 1996. 80,000 fans watched this women's sporting event—a first in history. At 15 she was the youngest player ever to play for the U.S. National Team. When the U.S.A. won the Gold medal in 2004 Olympics, Hamm announced her retirement from the National Team and started the Mia Hamm foundation for bone marrow disease.

Sarah Vaughan (1924-1990) was often called a singer's singer, influencing everyone from Mel Torme to Anita Baker. Known only as "Sarah," her voice remained strong throughout her nearly 50-year career. Jazz critic Leonard Feather called her "the most important singer to emerge from the bop era."

In 1913 Carolyn Van Blarcom of Illinois became the first licensed nurse midwife.

In May of 1776, a Congressional committee composed of George Washington, Robert Morris and George Ross, asked seamstress Betsy Ross to sew the nation's first flag. According to Betsy, George Washington showed her a rough design that included a six-pointed star. She reportedly demonstrated a quick method of cutting a five-pointed one—and the rest is history! Completed in late May or early June, the flag was officially adopted by the Continental Congress on June 14, 1777.

Attorney Priscilla Ruth MacDougall, former assistant attorney general for Wisconsin, was a vocal activist, participated in every major court case, beginning in 1972, concerning a woman's right to determine her surname after she marries. Ms. MacDougall and the U.S. Courts agreed that the U.S. law on names follows the common law of England, where a woman can keep her own name after she marries and can change it at will.

Bette Davis was the first woman to head the Academy of Motion Picture Arts and Sciences in 1941. In 1977 she was the first woman to receive a Life Achievement Award from the American Film Institute.

A noted social reformer, Dorothea Dix (1802-1887), investigated and instituted reform at jails, almshouses and mental institutions across the country. She played a major role in founding 32 mental hospitals, 15 schools for the feeble-minded, a school for the blind and numerous training facilities for nurses.

Althea Gibson was the first African-American tennis player, male or female, to win the French Open and Wimbledon. She broke the race barrier in 1950 when she played Forest Hills in New York.

In the 1930s Marabell Vinson Owen set a record for men and women by winning the women's U.S. National Figure Skating Championship nine continuous times.

Business woman Muriel Siebert became first woman to own a seat on the New York Stock Exchange in 1967. In 1975 her firm, Muriel Siebert and Company, became the nation's first discount broker.

The first woman to serve in both the House and the Senate was Margaret Chase Smith, a Republican from Skowhegan, Maine. She is also credited with having the longest incumbency of any female senator. She served in the House for nine years, from 1940—1949, and the Senate for 23 years, from 1949—1973. Ninety-five percent of the time she voted along Republican party lines, and she was the first Republican to verbally attack Senator Joseph McCarthy on the floor of the Senate.

Bonnie Blair, the fastest U.S. speed skater who ever lived, is considered one of the top ten winter Olympic athletes of all time. Winner of five Olympic gold medals, she is the first American to win three consecutive gold medals in any winter Olympics event for the 500 meter race.

Before her death in 1977, Heloise Bowles' syndicated column on household tips, *Hints from Heloise*, was one of the most popular columns in the history of syndicated women's features. She began writing for the *Honolulu Advertiser* in 1959 and was syndicated several years later. After her death, her daughter, Ponce Cruse, picked up where she left off and continued the column.

Jackie Joyner-Kersee is considered the best all-around athlete in the world, winning six Olympic medals (heptathalon gold in 1988 and 1992, long jump gold in 1988, heptathalon silver in 1984 and bronze in 1992 and 1996). Her sister-in-law, Florence Griffith Joyner ("Flo Jo"), won three Olympic gold medals (100-meter, 200-meter and 400-meter relay) and one silver medal (1600-meter relay) in 1988 in Seoul.

Peggy Fleming became the youngest person, at age 15, to win the U.S. Women's Figure Skating Championship in 1964. She went on to win a gold medal in 1968 at the Grenoble Olympics.

Geneticist Barbara McClintock, in 1951, found that genetic information could transfer from one chromosome to another, a key to understanding human disease. At age 81, she was awarded the Nobel Prize in Genetics.

The Seventh-Day Adventist Church was founded by Ellen White (1827-1915) and her husband James. They founded this Christian religion based on the accomplishment of spiritual and bodily health through nutrition and self-control.

Under Katherine Graham's direction, the *Washington Post* became one of the nation's leading papers. She won a Pulitzer Prize for Biography for her story, *Personal History*.

In 1870 Susan Smith McKinney Stewart became the first African-American woman medical doctor.

In 1963 Sarah Tilghman Hughes became the first female federal judge to swear in a U.S. President, Lyndon B. Johnson.

In 1925 Edith Nourse Rogers became the first woman to deliver the votes of the electoral college. Ms. Rogers was a Republican from Massachusetts who was reelected to her seat seventeen times. Ms. Rogers introduced the "G.I. Bill of Rights" Act and the Women's Army Auxiliary Corp (WAC) legislation.

In 1993, President Clinton, appointed Janet Reno to become the first woman to become Attorney General of the United States.

In 1973 Sister Elizabeth Edmunds made history by becoming the first nun to be a U.S. Navy officer.

Sally Victor of Scranton, Pennsylvania, was an innovator in the design of women's hats. She is known as the "first American hat designer." Ms. Victor made a great name for herself in the 1930s. During World War II, Ms. Victor designed women's work hats, which were a denim snood that held long hair and prevented accidents. One of Ms. Victor's most famous clients was First Lady Mamie Eisenhower.

In 1936 Majorie Gestring became the youngest person ever to win a gold medal in any Olympic event. She was 13 and won for the women's springboard event.

In 1929 Louise McPhetridge Thaden became the first woman to win a cross-country women's air derby (the first "Powder Puff" derby). Flying 2,350 miles from Santa Monica, California, to Cleveland, Ohio, she was able to cover the distance in twenty hours, nineteen minutes and ten seconds.

Between 1951 and 1954 Maureen Connolly did not lose a single tennis match. In 1953 she became the first woman to win the grand slam of tennis: Wimbledon, the Australian, French and U.S. championships.

The first trained nurse in the United States was Linda Richards of Massachusetts in 1873. She introduced the idea of patient records and uniforms for nurses and was a pioneer in industrial and psychiatric nursing.

Susan Warner became the first person to write a book that sold one million copies. In 1851 her first book, *The Wide, Wide World,* told the story of a motherless child who overcame many obstacles. It sold over one million copies in the U.S. and abroad.

Blues great Bessie Smith was one of the most celebrated entertainers during the 1920s. She became an overnight sensation after her first recording was released.

In 1910 Blanch Scott became the first woman to fly solo when a sudden gust of wind lifted the plane she was in forty feet in the air. She did go on to learn to fly and made her first cross-country flight, lasting 69 days, in 1912. She spent several years on the barnstorming circuit, making "death dives" (dropping from 4000 feet to 200 feet above the ground), earning up to $5,000 a week. As a guest of the U.S. Air Force, she became the first woman to ride in a jet fighter in 1948.

Great-granddaughter of Commodore Cornelius Vanderbilt, Gertrude Vanderbilt Whitney, became the first woman to found a major art museum. Having studied sculpture, she established an art studio in Greenwich Village. Her collection of contemporary art became the Whitney Museum of Art in 1931.

Engineer Yvonne Clark holds several important firsts. She is credited with being the first woman to receive a B.S. in mechanical engineering from Howard University, the first African-American woman in the Vanderbilt University Graduate School of Engineering Management and the first female African-American engineer to work at the Ford Motor Company glass plant.

In 1972 dancer and choreographer Judith Jamison became the first female dancer and the first African-American chosen to sit on the Board of the National Endowment for the Arts. Ms. Jamison danced with the Alvin Ailey American Dance Theatre and was once their artistic director.

People magazine called Mary Englebreit the "Norman Rockwell of the 90s." Her whimsical, nostalgic artwork adorns thousands of different products with upbeat designs. By 1997 sales of her cards and other items reached $100 million.

Dr. Condoleezza Rice became George W. Bush's National Security Advisor on January 22, 2001. Having served on the board of directors for Chevron, Charles Schwab Corporation, the William and Flora Hewlett Foundation and the University of Notre Dame among others, Dr. Rice has also been a professor of political science at Stanford University and won two of its highest teaching honors. In June 1999, she completed a six-year tenure as Stanford's Provost, serving as the institution's chief budget and academic officer. In 2005, Condoleezza Rice became President George Bush's Secretary of State, making her the first African-American woman to hold that position.

Mississippi University for Women in Columbus, established in 1884, was the first state college for women in the country.

Tennis star, Serena Williams, won the Wimbledon Singles Women title for the second year in a row in 2003. Her phenomenal winning streak is marred only by a loss at the 2003 French Open, making her record 40-1 for major tournaments dating back to the 2001 French Open.

Martha Stewart was born in Jersey City, New Jersey, in 1941, the daughter of a schoolteacher and pharmaceutical salesman. Her father, taught her gardening when she was only three. Her mother taught her cooking and baking and sewing. The retired bakers next door showed her how to bake pies and cakes. After college and careers as a model and stock broker, Martha started a catering business. In ten years, it became a million dollar enterprise, opening doors to her extraordinary chain of successful enterprises.

Hillary Rodham Clinton is the first, first lady elected to the U.S. Senate (in 2000) and the first woman elected statewide in New York.

Venus Williams has won career doubles Grand Slam with her younger sister Serena. She recorded the fastest serve in World Tennis Association history with a 127 mph blast. She won Wimbledon in 2000 and 2001 and took gold at the 2000 Olympic Games for singles and doubles tennis matches (with Serena).

Frances Perkins was the first woman to be Secretary of Labor and a cabinet member, serving under President Franklin Roosevelt. She championed social security, federal public works and relief, minimum wages, maximum hours and the abolition of child labor. She was responsible for unemployment insurance and the U.S. Employment Service. She served from 1933-1945.

The first female rural mail carrier in the United States was Mrs. Mamie Thomas. She delivered mail by buggy to the area southeast of Vicksburg, Mississippi, in 1914.

The Women's Book of World Records and Achievements, edited by Lois Decker O'Neill, Information House Books, Inc., New York 1979.

The Book of Women's Firsts, Phyllis Read and Bernard Witleib, Random House, New York, 1992.

www.ushistory.org/besty/flagtale.html

www.miafoundation.org/aboutmia.html

www.brightmoments.com/blackhistory/nsotrue.html

www.pbs.org/jazz/biography/artist_id_vaughan_sarah.html

www.nwhp.org/whm/themes/honorees03.html

www.cswnet.com

www.school.discovery.com/schooladventures/womenofthecentury

www.whitehouse.gov

www.achievement.org

SELECTED REFERENCES

www.hoover.archives.gov

www.greatwomen.org

www.girlscouts.org

www.forbes.com

www.oprahwinfrey.com

www.arethafranklin.com

www.theAmericanPresidency.com

www.idafinder.com

www.tennis-x.com

www.jfklibrary.com

www.hws.edu

www.loc.gov.

www.lpga.com

Collect all of these great PREMIUM PRESS AMERICA titles:

☐ I'LL BE DOGGONE
☐ CATS OUT OF THE BAG

☐ GREAT AMERICAN CIVIL WAR
☐ GREAT AMERICAN GOLF
☐ GREAT AMERICAN OUTDOORS
☐ GREAT AMERICAN GUIDE TO FINE
 WINES
☐ GREAT AMERICAN WOMEN

☐ ANGELS EVERYWHERE
☐ MIRACLES
☐ SNOW ANGELS
☐ THE POWER OF PRAYER

☐ ABSOLUTELY ALABAMA
☐ AMAZING ARKANSAS
☐ FABULOUS FLORIDA
☐ GORGEOUS GEORGIA
☐ MIGHTY MISSISSIPPI
☐ SENSATIONAL SOUTH CAROLINA
☐ TERRIFIC TENNESSEE
☐ TREMENDOUS TEXAS
☐ VINTAGE VIRGINIA

☐ TITANIC TRIVIA
☐ BILL DANCE'S FISHING TIPS
☐ AMERICA THE BEAUTIFUL
☐ DREAM CATCHERS
☐ STORY KEEPERS
☐ THE STORY OF GATLINBURG

Purchase other PREMIUM PRESS AMERICA titles where you found this one. If, for any reason, books are not available in your area, please contact the local distributor or contact the Publisher direct by calling 1-800-891-7323. To see our complete backlist and current books, you can visit our website at *www.premiumpressamerica.com*. Thank you.

Great Reading. Premium Gifts.